How to Master Portrait Painting in 24 Hours! A Seven-Step Guide for Oil Painting the Portrait Today

By: Jeremiah Jolliff

How to Master Portrait Painting in 24 Hours! A seven-Step Guide for Oil Painting the Portrait Today
Jeremiah Jolliff
www.ArtworkByJJ.com

Copyright (C) Jeremiah Jolliff 2015. All rights reserved

ISBN-13: 978-1516830725

ISBN-10: 1516830725

Jeremiah Jolliff is a fine artist from Ohio in the United States.

Today, Jeremiah works with artists and entrepreneurs from around the world, helping them to successfully create, publish and promote their work.

Jeremiah's primary focus is helping artists and entrepreneurs strategically position themselves. Achieving rapid growth of business by attracting ideal clients and charging higher fees.

This book is dedicated to my family for believing in me, my friends for their patience, and capitalism for making it all possible.

Thank you for a lifetime of support and encouragement.

"I dream my painting and I paint my dream."
-Vincent Van Gogh

"However one's mind may be elevated, and kept as to what is excellent, by the works of the Great Masters, – still Nature is the fountain's head, the source form whence all originality must spring."
-John Constable

"All you need to paint is a few tools, a little instruction, and a vision in your mind."
-Bob Ross

"Builders and warriors, strengthen the steps. Reader, if you have not grasped — read again, after a while. The predestined is not accidental; the leaves fall in their time. And winter is but the harbinger of spring. All is revealed; all is attainable."
-Nicholas Roerich

"The great secret of Freemasonry is that there is no secret at all."
-Benjamin Franklin

How to Master Portrait Painting in 24 Hours! A Seven-Step Guide for Oil Painting the Portrait Today **1**

Introduction 7

Chapter 1 How to Prepare Materials 11

Chapter 2 How to Draw a Portrait 29

Chapter 3 How to Go from Charcoal to Paint 33

Chapter 4 How to Develop an Underpainting 39

Chapter 5 How to Develop the Painting 43

Chapter 6 Develop the Painting Further 46

Chapter 7 How to Finish a Portrait 49

Chapter 8 A Quick Exercise and Conclusion 53

Acknowledgements 57

Further Reading and Bibliography 60

Introduction

I would like to discuss how this book came about. This book developed from a workshop I attended at the Florence Academy of Art in Mölndal Sweden. The instructor who taught the course was Stephen Bauman. He is the best instructor on oil painting the portrait today. This book is an accumulation of workshop handouts, extensive personal notes from the workshop and Stephen Bauman's excellent instruction. If the artist reading this book is desirous of studying art, The Florence Academy of Art is the only place for a fundamentalist.

This book is organized into seven-steps and expedites the reader into the craft of oil painting the portrait. The first step is to gather materials and then move seamlessly into the next steps. The last part of the book is a short exercise where the artist can practice before attempting a live portrait. Completing the short exercise builds confidence and helps the artist become accustomed to the process.

The reader will be relieved that this seven-step guide is easy to follow and gives the artist tools to produce a portrait using "imprimatura." Imprimatura is an Italian word meaning "first coat." Stephen describes imprimatura as the process of applying a first coat onto the canvas in order to mute the white of the canvas' ground allowing the artist to more easily gauge the values whilst painting.

The purpose of this book is to save the artist time and give them direct advice without the fluff.

The journey to writing this book has been long and enjoyable. Modern art has pretty much wiped out the knowledge of the craft of painting. If it weren't for fine artists like Stephen Bauman and institutions like The Florence Academy of Art, these techniques would still be largely unknown to the masses. For that reason, I would like to say thank you to Stephen and the Academy.

I read many old books on portrait painting after the workshop. The artists of old, humans of great renown, were able to produce high forms of art with a limited palette. During the workshop we were taught how the masters painted with a limited palette and the results were amazing. It is my hope that the artist can learn to paint with this limited palette in order to understand the process before attending a workshop with Stephen Bauman or The Florence Academy of Art.

Also, formatting this book was a challenge. If there are mistakes, my fault...

If you want free tips and would like to contact me, go to my website now and opt-in: http://www.artworkbyjj.com/

All of my artwork is available for sale as originals and prints, along with painting tutorials, recommended products, and more.

My Website: http://www.artworkbyjj.com/

https://www.facebook.com/ARTWORKBYJEREMIAHJOLLIFF

Blog: https://jjolliffblog.wordpress.com/

Twitter: https://twitter.com/jeremiahjollif

Youtube: https://www.youtube.com/channel/UCsauBxqWjjow6bCKl7DgRHA

LinkedIn: https://www.linkedin.com/in/jeremiahjolliff

Google+: https://plus.google.com/u/0/+JeremiahJolliffartwork/posts/p/pub

Instagram: https://instagram.com/jeremiah_jolliff/

Pinterest: https://www.pinterest.com/jeremiahjolliff/

Chapter 1 Step 1 - How to Prepare Materials

Materials

It is overwhelming trying to figure out what to purchase for portrait painting. Everyone's advice is different. Art suppliers market all kinds of materials that are unnecessary. The following is *the* definitive list of supplies required. In this chapter, I will give the complete list of items that are necessary for a successful portrait. I will list the items and then give short descriptions thereafter. After the descriptions, I will describe how to prepare the materials before beginning a portrait. Organization is a necessity. Here is a list to make it easy.

Materials list:

Sturdy Easel

11" x 14" canvas boards

#4 Hog Bristle Filbert Brush (2)

#3 Hog Bristle Filbert Brush (2)

#2 Hog Bristle Filbert Brush (2)

Wooden Shish-kabob skewers

Palette Knife

Palette

Paper Towels

A container for medium

Turpentine

Linseed Oil

Stand Oil or Black Oil

Neutral colored shirt to wear whilst painting

Vine Charcoal & knead-able erasers

Plumb Line

Viewfinder

Mirrors

Titanium White

Yellow Ochre

Terra Rosa

Raw Umber

Ultramarine Blue

Mars Black

Descriptions of Materials

Sturdy Easel- The importance of a good sturdy easel cannot be stressed enough. It pays dividends to have an extremely stable support upon which to paint.

11" x 14" canvas boards- an 11" x 14" canvas board is the perfect size onto which a portrait can be painted. The 11" x 14" frames the head perfectly and is close to life size and thus adds to the believability of the portrait.

Brushes- In regards to the hog bristle brushes; it is a good idea to have two of each size. Keep one for painting light and the other for painting in dark values. Having two brushes of each size will greatly aid the artist in working efficiently. Two brushes help the artist to work efficiently because there is no need to constantly clean brushes when

switching between light and dark values. Don't use sable brushes. Use the old-fashioned bristle brushes. When using the painting medium described below, the brushstrokes will disappear because the painting medium levels out when the paint is allowed to sit upon the canvas undisturbed and is allowed to dry.

Mirrors- a white mirror or regular mirror is used during the block in stage. The mirror should be small about 3" x 5". It is used by simply holding the mirror between the eyes with the mirrors edge inline with the bridge of the nose. One eye is used to look at the model while the other eye looks at the mirrors reflection. Using a mirror helps the artist see proportions correctly. If more information is required, look up how to use a mirror in the "sight-size" method. A black mirror is handy in the later stages in order to find out the value relationships on the models face.

Viewfinder- helps the artist frame in the face and is very useful because it allows the artist to see what the portrait should look like compositionally on the canvas.

Plum Line- The plumb line is a piece of string with a weight on one end and is used to determine the absolute vertical line relationship on the face (i.e. the inside corner of

the eye passes to the outside of the nostril but to the inside of the corner of the mouth, etc.) The string of the plumb line can be used to measure distances upon the face as well.

Wooden Shish Kabob Skewers- skewers are excellent to redefine important areas and erase excess paint especially in and around the eyes and hard to define areas like the nostrils and grisly parts of the ears.

Palette Knife- a flexible medium sized palette knife will do the trick. The best are tapered towards the end, are flexible and help the artist to not only mix paint on the palette but scrape out areas upon the canvas.

Palette- a palette made of wood is best. I suggest buying a medium sized palette and coat it several times with linseed oil before using it. As time goes by, the palette will begin to take on a very neutral grey color. Having a good, aged palette helps the artist to determine color & value more accurately.

Paper towels- secure a whole roll of cheap paper towels. Having a large quantity of paper towels pays dividends because they can be used for things unimaginable.

Container- There are small metal containers that have a clip on them that can be utilized to clip directly onto the

palette. The container is used to hold the painting medium described below.

Turpentine- high quality turpentine is a necessity. Do not buy turpenoid or odorless mineral spirits.

Linseed oil- the artist should purchase only artist's grade linseed oil.

Stand Oil or Black Oil- taken together with a high quality linseed oil makes a great medium for portrait painting.

Neutral colored shirt- it is a good idea to wear a neutral, usually earth toned shirt. If the shirt is bright or a lively color, there will be a reflection onto the wet paint and upon the canvas.

Vine Charcoal & knead-able erasers- vine charcoal erases easily and knead-able erasures can easily remove charcoal dust.

Oil Paint- Purchase artist grade color only. Do not purchase student grade color because there is too much filler in student grade oil paint and the tinting strength is greatly reduced thereby. Go ahead and commit to buying the higher

quality paint. The pain brought to the pocket book by purchasing materials may act as a catalyst to make one paint more often.

How to Prepare the Materials

How to apply the "Imprimatura" to the Canvas Panels- in the studio the night before, lay out a bunch of those 11" x 14" canvas panels, turpentine, a big paint brush, palette, paper towels, and last but not least, raw umber & yellow ochre.

Take the raw umber and put a small pile of it onto the palette. Add to this pile a modicum of yellow ochre to enliven the color and give it energy.

Next, pour a small quantity of turpentine onto the palette with the raw umber and yellow ochre.

Take a big paintbrush and mix it around on the palette until the consistency is thin & uniform.

Apply the mixture onto the canvas boards & wipe off the excess with paper towels.

The Raw umber and yellow ochre should be fairly transparent on the canvas panel boards. The turpentine acts as a dryer for the raw umber and yellow ochre imprimatura. The canvas panel will be dry in a few hours.

These raw umber and yellow ochre imprimatura canvas boards are excellent to paint upon. The reason for this is because when a painter paints cool colors onto a warm background, it produces a scintillating sensation. Once the painter experiences that joy first-hand, it is never forgotten.

Most portrait scenes are very cool in nature: cool blue shadows, relaxing pink flesh tones, strange or eerie grays. When the painter paints these forms into a raw umber and yellow ochre toned board, the wow factors goes through the stratosphere.

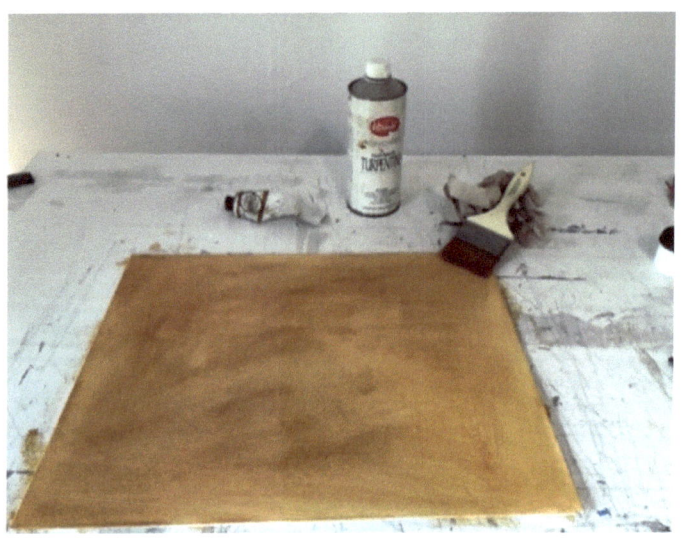

How to prepare the flesh tones

How to prepare the pink-red flesh tones- For the pink-red flesh tone the mixture is straightforward enough and consists of: mars black, terra-Rosa, a modicum of ultramarine blue, a modicum of yellow ochre & titanium white to create the value scale of six shades. Here is a picture for your reference.

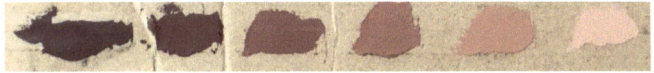

How to Prepare the yellow-gray flesh tones-

The yellow-gray flesh tone is pretty simple to prepare. Simply add these colors together: mars black, raw umber, a modicum of yellow ochre to calm it down, and titanium white to create the value scale. The second color from the left is pure raw umber. Here is a picture for your reference.

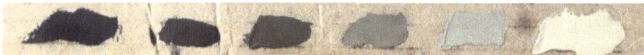

How to Prepare blue-purple flesh tones-
blue-purple is made by mixing: mars black, ultramarine blue, terra-Rosa, a modicum of yellow ochre, and titanium white to create the value scale. Here is a picture for reference.

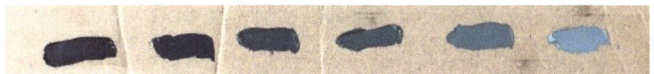

How to Prepare the Palette- Lay out the palette in this order from the top row left to right: mars black, ultra-marine blue, raw umber, terra-Rosa, yellow ochre, and titanium white. The second row is the pink-red flesh tones arranged from the darkest value to the lightest value. The third row is the yellow-gray tones arranged from the darkest value to the lightest value. The fourth row is the blue-purple tones arranged from the darkest to the lightest value.

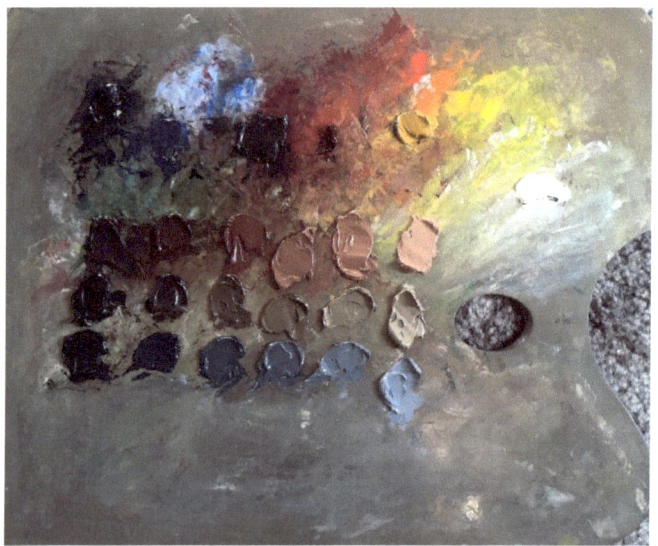

How to prepare the medium- The painting medium is used to thin the paint down enough so that it flows off the brush more easily. Take about 45% linseed oil, 45% stand oil and 10% turpentine. The turpentine is optional. Put them in a small container and mix together. If one adds more turpentine the concoction will dry more quickly. If one adds more linseed oil the concoction will dry more slowly. This medium is self-leveling. That means that by the time the medium dries, the brush strokes will disappear.

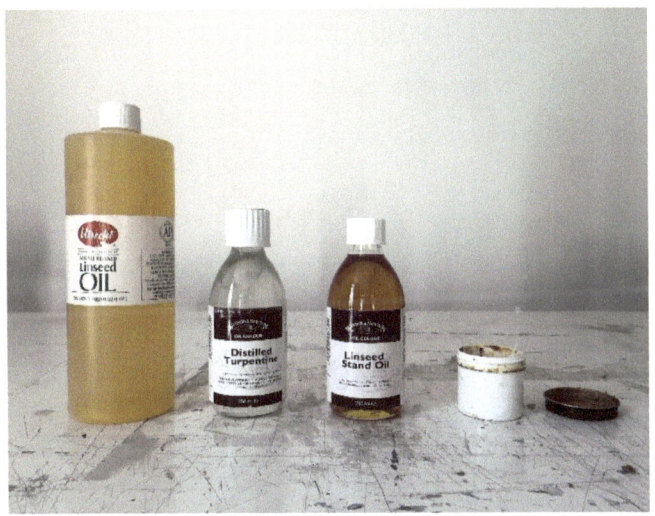

Chapter 2 Step 2 - How to Draw a Portrait

How to Draw a Portrait

Well, I am now going to let the cat out of the bag. The title of this book could be considered misleading. Portrait painting cannot be mastered in 24 hours. However, if an artist breaks down the portrait into eight, three-hour sessions, the results will be fantastic!

The first session should last about three hours and the artist should use only charcoal to establish the drawing onto the previously imprimatura prepared canvas board. Do not use a picture, trace a picture or use a projector. That is not painting. A painter paints from life & life only.

The first session is usually the most critical. Setting up the model is half the battle. In the classic set up, the light source should be from ten o'clock or from two o'clock. When the light source is from either ten o'clock or two o'clock, the shadows cast upon the face are very aesthetic. For example, the shadows under the chin, nose and the hollows of the eyes are very rich and easily defined. Having easily defined shadows aids in creating the illusion of depth and are easier

to draw. "This forcing of dark against light and light against dark in the pattern of masses, throws up the form" (speed 186).

Another key aspect of setting up the model is to have the model turn their head about 45 degrees. Having the model sit and stare dead ahead is boring. Kilter their body away from you slightly and have their head turning in the opposite direction. Instruct the model to find a spot to look at that is slightly above them so that their eyes are cast slightly upwards in the same direction that their head is turned.

Interesting clothing and/or headgear often aid in the composition. For your first couple portraits, it is suggested to use neutral colored clothing and headgear. Later on, however, the artist should run riot with colorful attire adorning the model.

Stephen suggests using Nitram charcoal because it is the highest quality charcoal and can be sharpened to a chisel tip. He suggests using H, HB or B and a piece of sandpaper to create a fine point to draw with. Any type of charcoal works but Nitram is best.

Using the viewfinder, frame in the model's head. This step is important because framing in the model's head with the

viewfinder helps the artist determine the most pleasing composition. Make marks on the viewfinder annotating where the top of the head is and where the chin is located. The artist should attempt to capture the entire face leaving about two-to-three inches of space above the head. The composition should extend all the way down below the collarbones or breastplate. Having all those elements makes the portrait more believable and stops the head from *floating* in the composition.

The charcoal drawing is the foundation onto which all the beautiful color and brushwork will be applied. As such it is extremely important. Blocking in the head can be achieved easily by first establishing the largest shapes. It is useful to establish the important structural landmarks of the head.

The artist should constantly be questioning themselves on the location of the: line of the brow, bottom of the nose, bottom of the ears, jaw line, pit of the neck, tear ducts of the eyes, the outside of the eyes and last but not least the muscle that extends from behind the ear to the pit of the neck (this muscle is called the sternocleidomastoid).

The artist must establish these relationships correctly in order to create the symmetry that creates a likeness of the model. Ask: "are the earlobes above or below the shadow of

the nose? Where are the corners of the mouth located in relation to the tear ducts of the eyes?"

Besides the landmarks listed above, there are secondary landmarks that need established. These include: The shadows and their shapes below the eyebrows, the nose, the bottom lip and underneath the chin.

In order to find these secondary landmarks or shadow shapes, the artist should squint their eyes and look upon the model. When the eyes are squinted, the shadow shapes melt together. In other words there are no half-tones there is only the light shape and the shadow shape.

Before ending the day, take some masking tape and place it on the floor to help mark where the chair was and use whatever method available to enable the pose to be consistent during the next sessions. The drawing or block in should be taken to about the level shown here below:

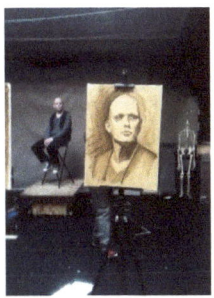

Chapter 3 Step 3 - How to Go from Charcoal to Paint

How to Go from Charcoal to Paint

The second session in the process should also last for three hours. The artist needs only one color on the palette and that color is raw umber and a small quantity of the medium mentioned earlier (45% Linseed Oil + 45% Stand or Black Oil + 10% Turpentine).

Before doing anything, take a short time to actually look at the model and then look at the canvas. Think in simple geometric terms: "the shape under the neck is rectangular and the shadow shape under the nose is similar to a triangle." Shore up any inconsistencies between the model and the charcoal drawing. This process should take only about fifteen minutes.

It is important to look at the model with fresh eyes. It is surprising how many blatant mistakes there could be. The great thing about working in charcoal is that the mistakes can be quickly corrected without making a mess.

Moving from charcoal and into paint can be a stressful and exciting venture. Allow me to put the artist at ease here with this advice: "thin the paint down with the medium and have a very small amount of paint on the brush." The paint will be thinned quite a bit and the brush itself will actually have very little paint. The brush should be almost dry in fact when re-establishing the charcoal drawing with raw umber.

Block in the large shadow shapes first. The largest shadow shapes will be the shadows under the eyebrows, the nose, and especially under the chin. Continue working in this manner beginning with the largest shadow shapes and moving towards the smaller shadow shapes, half tones, highlights and lastly the details like the eyes, ears, nose, and mouth. Use the wooden skewer at this stage to "erase" the outlines of the eyes, tear ducts, nostril and the grisly parts of the ears.

There is one other point that needs mentioning here and that is the handling of edges. The areas of light and dark are defined by edges. Some edges are hard. Hard edges occur where the form turns away from the light drastically. These areas include the shadow shapes that are tucked up underneath the hollow of the eyes, shapes under the nose, and areas deep underneath the chin.

Some edges are soft. Soft edges occur where the form turns away from the light source gradually. These areas can be seen most often around the jaw line. Use a finger to soften these edges. In other words, soft edges are often the characteristic that really separates a good painting from a great painting.

Lastly, there are lost edges. Lost edges are edges that seemingly have no edge. These lost edges occur most often below the check bone and are created by the form turning away from the light source but the forms never turn completely away from the light source.

Every time the artist approaches a new session, they should work to re-establish these shadow shapes and then work from the shadow to light. There are many metaphors in this method: "from darkness to light."

It is also advisable to establish the highest highlights. To do this, there are a couple of options. The first option is to take an eraser and attempt to scrub out the highest value highlights so that the raw umber and yellow ochre imprimatura of the canvas is removed; thus allowing the bright white of the canvas to show through again.

Another option is to take a paper towel or lint free rag and dip the tip into a bit of the medium. The medium acts as a

solvent and allows the raw umber and yellow ochre imprimatura to lift from the canvas.

The highest highlights invariably occur on the forehead directly above the eyebrows, the tip of the nose and the prominent part of the chin.

By the end of the second session on the first day, the artist should have a solid six hours of work invested into the portrait. The artist should be looking for results that are pretty much inline with the picture below.

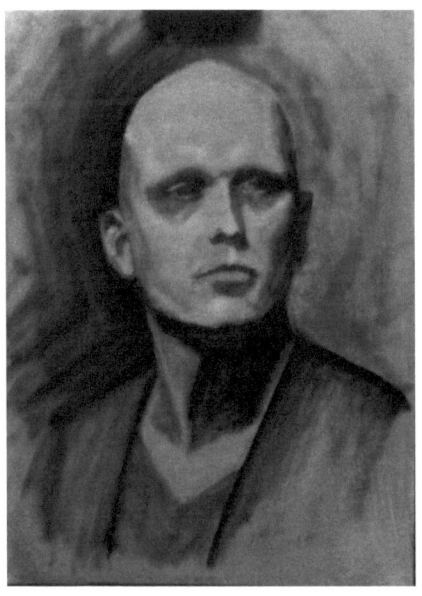

Chapter 4 Step 4 - How to Develop an Underpainting

How to Develop an Underpainting

The first two sessions should be completed on the first day.

The third session should begin the morning of the second day. During the overnight hours the paint on the canvas should dry somewhat but should still be a bit tacky. The paint should be dry enough so that it does not lift off the canvas when the next layer is applied. As the paint is applied in thin layers, something peculiar happens. Since the paint is thinned with the medium, there is a translucent quality. That translucent quality creates the illusion of light. As the next layer of thinned paint is added, another translucent layer of paint captures even more light.

During this session the artist should lay out a full palette with the colors: mars black, ultramarine blue, raw umber, terra-Rosa, yellow ochre, and titanium white.

Lay out the pink-red mixture, the yellow-gray mixture, and the blue-purple mixture in six matching tonal values. That means if someone were to take a black and white photograph of the palette they would not be able to

distinguish between the colors on the palette because they would all look the same when seen on the gray scale of a black and white photograph.

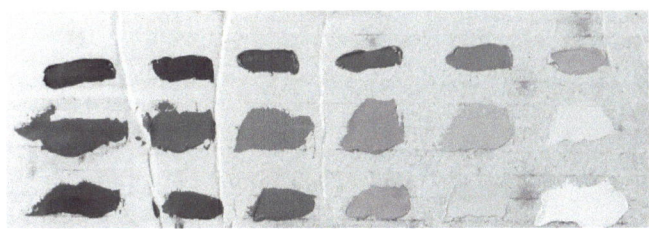

The third session, or the morning session on day two, should be characterized by using only the pink-red tones and the yellow-gray tones.

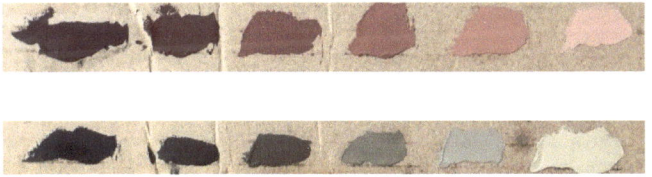

The process is always the same. Take some time to look at the model and become acquainted with the shadow shapes and light forms.

The artist should be looking at the big picture. In other words, "do the earlobes extend below the nose? Where are the outsides of the eyes in relation to the outside corners of the mouth?" Do the corners of the eyes extend to the left or

right of the outside of the mouth, etc?" Look for the landmarks and their relationships to each other.

Re-establish the shadow shapes. Beginning in the shadow and moving toward the light will characterize every portrait painting session. Using the values from the pink-red tones and the yellow-gray tones, the artist can begin to move from the monochrome raw umber block in phase and into the underpainting phase.

It is important to continue using very thin paint and the brush will be almost dry. Look at the model and determine which shadows are warm and which shadows are cool. For example, under the chin the shadow is usually very cool but the shadow underneath the nose is usually somewhat warmer because the light penetrates that area and imbues it with heat.

The tones created earlier match each other in terms of value. When different colors of equal value are mixed, they create a perfect gray. These grays in a portrait are what make the viewer intrigued. These gray layers or films must be applied slowly and applied thinly so that it adds to the overall effect. Concentrate on re-establishing the drawing and remember to look often at the model. With each session the layers will begin to give life to the portrait as long as the layers are kept

thin and controlled. Allow portions of the imprimatura to be seen through the thinned paint. That creates scintillation.

Work in this manner for about three hours, working from dark to light and taking a break every hour for about ten minutes in order to see the model with fresh eyes.

During the second session on day two, the artist must establish the background, the darkest dark on the model and the lightest light on the model. Once the darkest value on the model is established, usually the cast shadow on the neck under the chin, all other values should be compared to that darkest value. The artist should ask themselves: "is that dark under the chin darker than the dark under the nose?"

There is a bit of a trick that the old masters used to really help the portrait "pop." They would make the background much darker than one would expect on the light side of the models face but make the background lighter on the dark side of the models face. In other words, make the background dark on the light side of the model but light on the dark side of the model.

Use a skewer to re-establish the details around the eyes, nose and ears. By the end of the second day the portrait should be coming along nicely and rendered to about the level shown here:

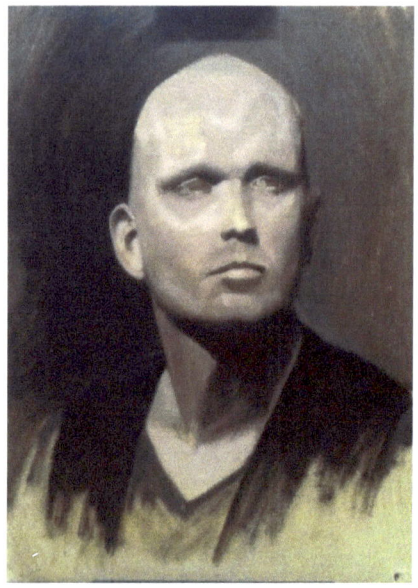

Chapter 5 Step 5 - How to Develop the Painting

How to Develop the Painting

Great! Welcome to day three or the twelfth hour. At this point the artist should have about twelve hours invested in the portrait. That means there are only twelve hours left to master portrait painting!

It should come as no surprise that the artist must once again work from the shadow to the light. Keep the paint thin and establish the darkest shadows again.

At this stage the artist starts to bring it all together! They have created a great charcoal drawing, established the block in using raw umber and have even begun to add flesh tones over the imprimatura canvas. The fifth stage is characterized by adding the blue-purple tones onto the canvas.

The blue-purples really add life to a portrait. However, it is important to keep in mind that not every shadow on the face has a great quantity of this blue-purple tone.

This chapter is short because the method of working in this manner has already been mentioned in the previous chapter.

I do not intend to belabor the points previously made but rather desire to expand upon them slightly. When working from dark to light, it forces the artist to move all over the canvas instead of lingering on one area. The artist should have a game plan to counteract this tendency. Start from the darkness and re-establish these shadow shapes paying particular attention to the drawing of their edges.

When developing a painting above the level of a mere underpainting, the artist should begin to see how cast shadows are sharper at the place of their origin, and how they gradually soften the further they are from the form that cast them.

Stephen made it very clear to us that this stage should be characterized by: "keying up the values. When keying up the values, select an area of high contrast. Establish the value relationship in this area and then relate all other values of the painting." In other words, find the darkest dark, work from that area until reaching the lightest light. The black mirror is the perfect tool to find out what part of the portrait is the darkest value.

Work slowly and methodically keeping the paint thin and the brush laden with only a small amount of paint. Before ending for the day, add some variety to the background

using visceral brushstrokes. Keep the darkest value in the background darker than expected but keep the darkest value in the background one or two steps lighter in value than the darkest value on the portrait. In other words, the darkest dark on the model will be the darkest value throughout the entire composition to include what is painted in the background. The same holds true for the lightest value. The lightest value should be on the portrait and should not have to compete with the lightest value in the background.

Be sure to make ample use of the wooden skewer to re-establish the detail of the eyes, nose and mouth. By the end of the third day the portrait should be rendered to about the level shown here below:

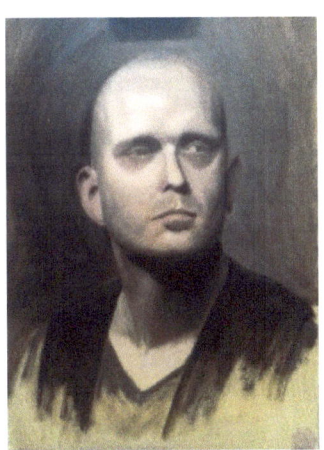

Chapter 6 Step 6 - Develop the Painting Further

How to Develop the Painting Further

At this point the artist should have around 18 hours invested in the portrait. There are only two more sessions left. That means the artist should have around six more hours to work.

If the artist is new to this method, they should be pretty proud of what they have achieved thus far. Taking time and viewing color as value will characterize this session; communicating what that actually means is somewhat difficult.

Let us assume that we have a very warm pink under the eyes. Usually a fine pink is considered to be a very light color but on the gray scale a pink can still be a very dark value. If the artist were to squint down and look at the models eye sockets, they would see an area of shadow that describes the concave nature of the eye socket. When the artist views the model with fully open eyes however, all they see is a vibrant pink!

The trick is to use that color seen with the open eye but produce a value that matches the shade of the eye socket

whilst their eyes are squinted. The same holds true for every part of the portrait.

It is my hope that that makes sense to the reader.

As in all other sessions, the artist should begin working from the darkest portion of the portrait and move to the lightest portion. The tendency for many artists is to consider the portrait complete but nothing is more distant from the truth. They have to re-establish the drawing, re-establish the shadow shapes, and at this stage finally begin the process of seriously imbuing the shadows with etheric color.

The build up of painted layers takes time and dedication. Through the entire process, the artist has become extremely acquainted with the positions and relationships of the models features. This intimacy is the factor that really charges the portrait and gives it life.

There are no short cuts when attempting to paint as the great masters of the past. If someone makes claim there is a shortcut, they are a charlatan. It is easily seen when viewing a portrait painted from a photo. The portrait painted from a photo has no soul, much like the person who created it.

Session by session the artist builds upon what they have created in the previous session. The goal of this session is to

build richness into the shadow shapes, dark half-tones, light half-tones, highlights, and to have completed the background. The highlights closest to the light source will always be the brightest (i.e. the forehead).

Chapter 7 Step 7 - How to Finish a Painting

How to Finish a Painting

During all other sessions the artist should be using the tones of color aforementioned (i.e. the pink-red, yellow-gray, & blue-purple tones). During the final session, the artist may find it to their advantage to actually begin working with the raw colors on their palette (i.e. mars black, ultramarine blue, raw umber, terra-Rosa, & Titanium White).

Keep the paint thin in the shadows but as one moves into the light half-tones and into the highlights the paint can be fat. When the paint is thin in the shadows but fat in the light, it gives the portrait a three dimensional quality. A good example of this technique can be seen in the works of Rembrandt. The highlights often look like cake icing and are very thick but the shadows are kept very thin and recede. On close inspection, the old masterpieces are similar to relief sculpture.

When paint is used straight from the tube it is vibrant because the Chroma of the paint is undiluted. Chroma is the measure of how pure or intense or how saturated the color is.

There is a great advantage in using only the flesh-tones prescribed to build up the portrait. Once the artist moves into using the colors directly from the palette, it saturates the entire portrait and captures realism exponentially better than some mere photograph. The portrait should be rendered to the level seen here.

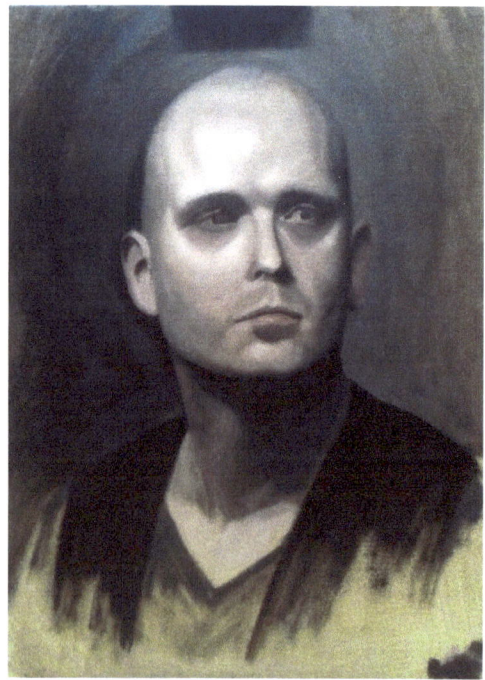

Chapter 8 A Quick Exercise and Conclusion

A Quick Exercise and Conclusion

A Quick Exercise

Copy this drawing on the following page with charcoal, re-establish the charcoal drawing with raw umber, next use the pink-red and yellow-gray tones to establish an underpainting, then move in with the blue-purples to enliven the color and vivacity of the portrait and finally finish the painting by concentrating on the eyes, nose and mouth using color straight from the palette.

The portraits original size was 11" x 14". It is suggested to copy it onto an 11" x 14" canvas thus keeping the proportions the same in the composition. Remember to take time and make an accurate drawing and paint in extremely thin layers allowing the paint to dry slightly between each session. Do not trace. Do not use a projector. If the drawing fails, all is lost. Use restraint and do not use thick paint until

the very end and only on the areas of the highest highlights. Good luck.

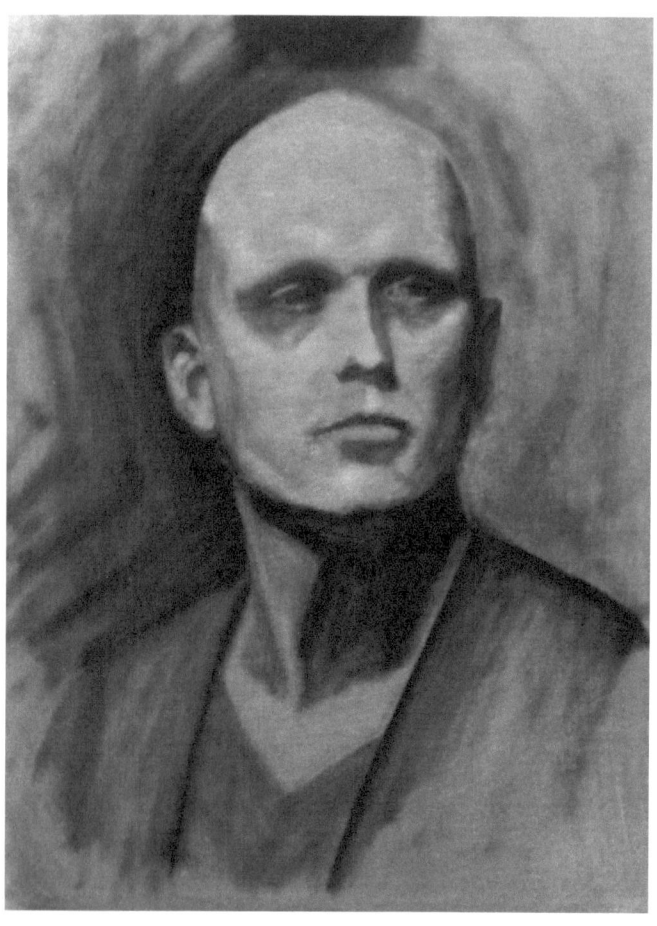

A Quick Conclusion

Well, thank you for reading this book. Everyone has a different system for painting. This system of portrait painting is based on the masters of the past, especially Rembrandt, and is taught currently by the outstanding instructors at The Florence Academy of Art. I would like to extend my appreciation to Stephen Bauman in particular for teaching an excellent workshop. Thank you.

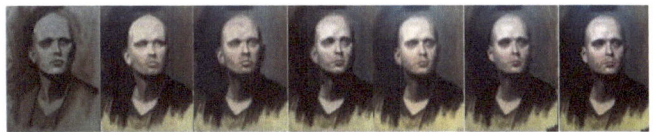

Please rate and write a review of this book online.

Acknowledgements

I would like to acknowledge all my art teachers I have had in the past; especially Mr. Gary Erbaugh. He was my Art teacher in High School.

So you made it through this little book? I am very glad that you did. Hopefully the instruction given will be useful. If you have particular questions, please find me online for additional resources. I look forward to seeing what will be created from this creation.

All of my artwork is available for sale online as originals or as prints, along with painting tutorials, recommended products, and more.

My Website: http://www.artworkbyjj.com/

Facebook: https://www.facebook.com/ARTWORKBYJEREMIAHJOLLIFF

Blog: https://jjolliffblog.wordpress.com/

Twitter: https://twitter.com/jeremiahjollif

Youtube: https://www.youtube.com/channel/UCsauBxqWjjow6bCKl7DgRHA

LinkedIn: https://www.linkedin.com/in/jeremiahjolliff

Instagram: https://instagram.com/jeremiah_jolliff/

Pinterest: https://www.pinterest.com/jeremiahjolliff/

Further Reading and Bibliography

Carlson's Guide to Landscape Painting
By John F. Carlson
(C)1929
> This is the definitive guide to Landscape Painting that the serious painter should already have in their collection. If they do not have it, then they should go buy it immediately.

Hamlet's Mill, An Essay on Myth and the Frame of Time
By Giorgio de Santillana and Hertha von Dechend
(C)1969
> This is a great book that will illuminate the mind to the natural events that gave birth to this era of increased productivity.

Landscape Painting
By Asher B. Durand and Birge Harrison
(C)2013
> A collection of Letters on Landscape Painting from Asher B. Durand with an original copyright of 1855 and the second part of the book is a reprint of Birge Harrison's book entitled *Landscape Painting*. This book is only for the individuals who have been initiated by their artistic practice out in nature.

The Practice & Science of Drawing
By Harold Speed
(C)1924

 A heavy duty treatise on the craft of drawing and its more esoteric applications. Fortunately this is a mandatory book for the serious artist engaged in real life art making.

Oil Painting Techniques and Materials
By Harold Speed
(C)1924

 This is the unofficial follow up and sequel to the aforementioned book by the same author.

The Practice of Oil Painting and Drawing
By Solomon Joseph Solomon
(C)1911

 Solomon Joseph Solomon's tour de force; before the modern artist and charlatans ransacked the philosophical house of painting, S.J.S. hid the jewels away in this work in the hopes that one day more illuminated benefactors would recover the craft of painting.

www.ingramcontent.com/pod-product-compliance
Lightning Source LLC
Chambersburg PA
CBHW040815200526
45159CB00024B/2991